FABULO FLOWERS

SUSAN BLOOMENSTEIN

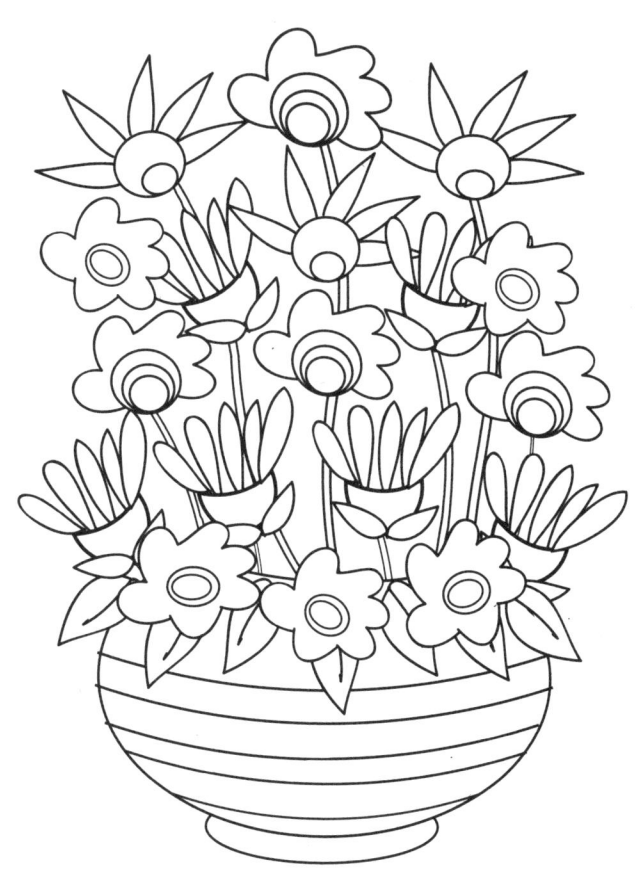

DOVER PUBLICATIONS, INC.
MINEOLA, NEW YORK

At Dover Publications we're committed to producing books in an earth-friendly manner and to helping our customers make greener choices.

Manufacturing books in the United States ensures compliance with strict environmental laws and eliminates the need for international freight shipping, a major contributor to global air pollution. And printing on recycled paper helps minimize our consumption of trees, water and fossil fuels.

The text of this book was printed on paper made with 50% post-consumer waste and the cover was printed on paper made with 10% post-consumer waste. At Dover, we use Environmental Paper Network's Paper Calculator to measure the benefits of these choices, including: the number of trees saved, gallons of water conserved, as well as air emissions and solid waste eliminated.

Courier Corporation, the manufacturer of this book, owns the Green Edition Trademark.

Please visit the product page for *Fabulous Flowers* at www.doverpublications.com to see a detailed account of the environmental savings we've achieved over the life of this book.

NOTE

This coloring collection of interestingly abstract flower designs is ideal for artists of all ages, and perfect for experimenting with color. Artist Susan Bloomenstein's playful interpretations of daisies, tulips, sunflowers, and other flora are backed by a wide array of geometric patterns. Perforated pages make it simple to display your finished work.

Copyright
Copyright © 2013 by Dover Publications, Inc.
All rights reserved.

Bibliographical Note
Fabulous Flowers is a new work, first published by
Dover Publications, Inc., in 2013.

International Standard Book Number
ISBN-13: 978-0-486-49158-5
ISBN-10: 0-486-49158-7

Manufactured in the United States by Courier Corporation
49158701
www.doverpublications.com

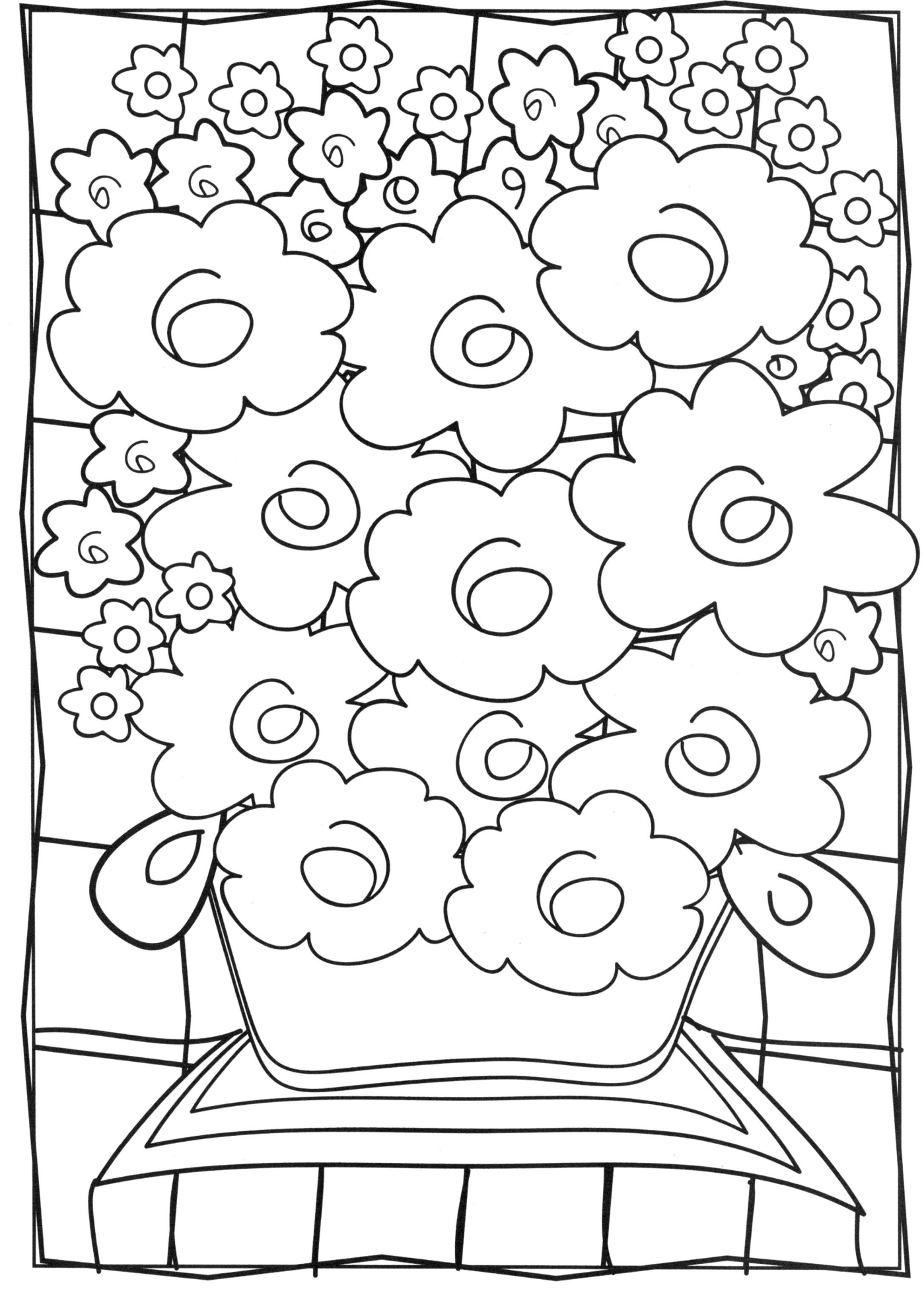

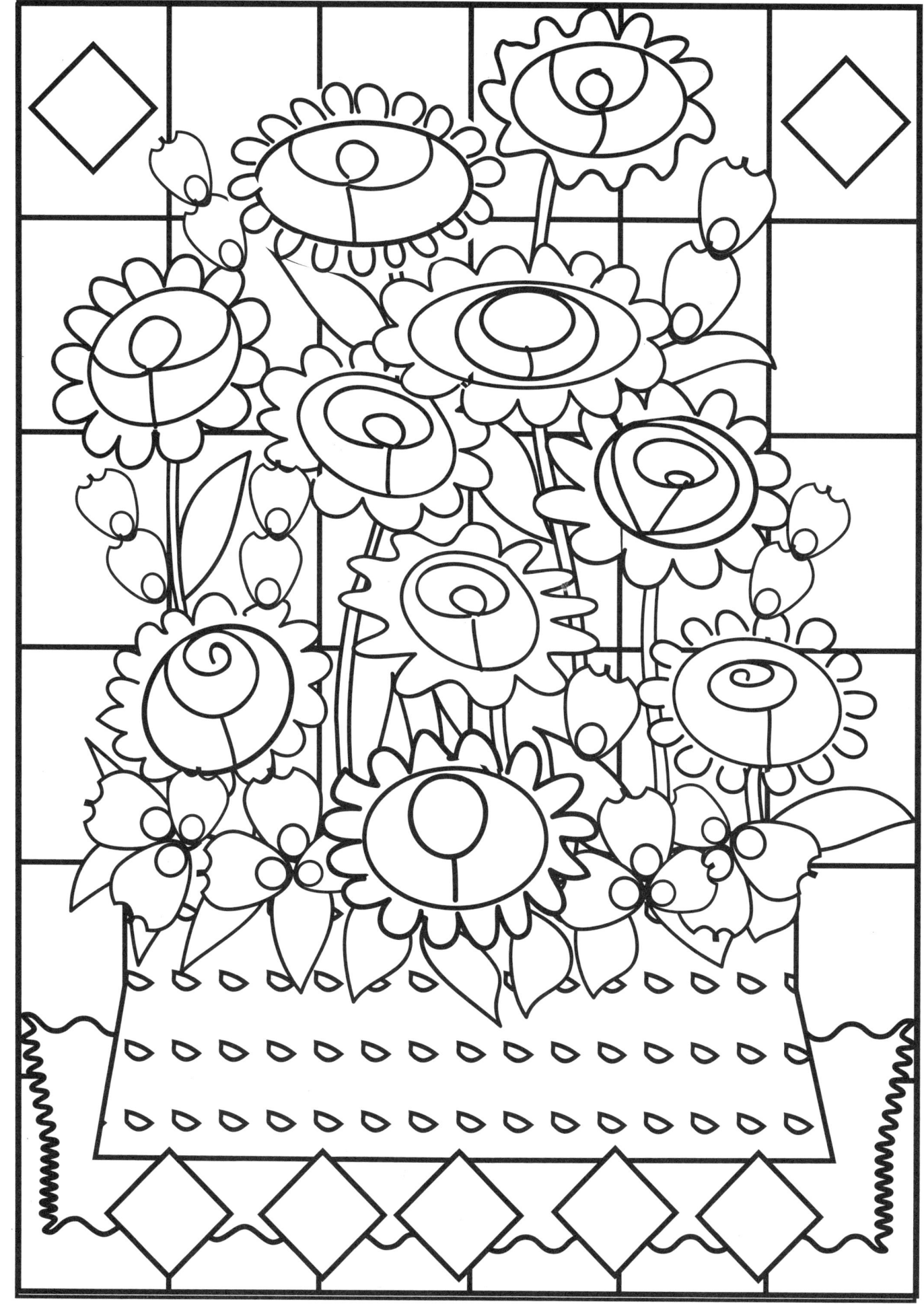

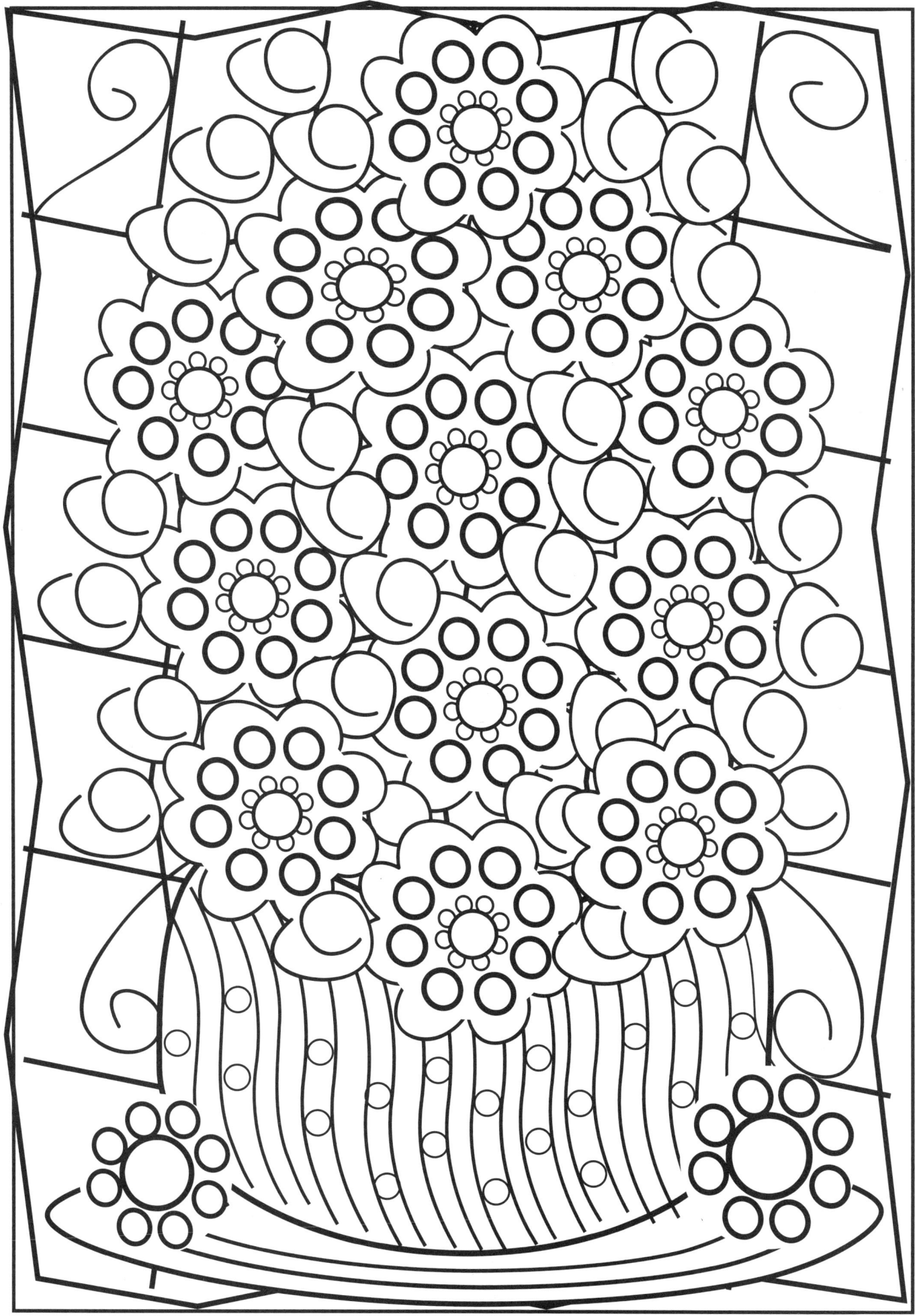

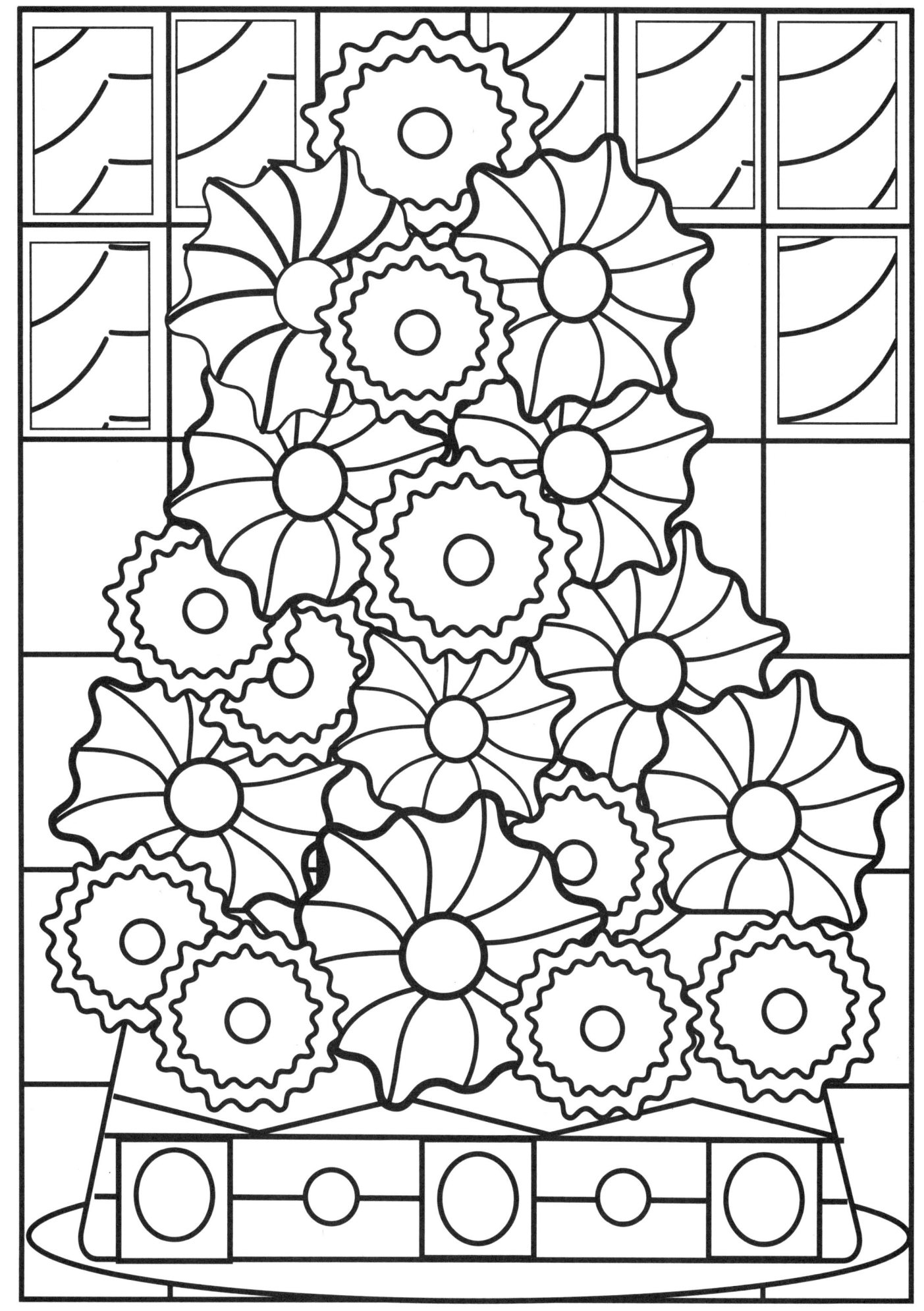

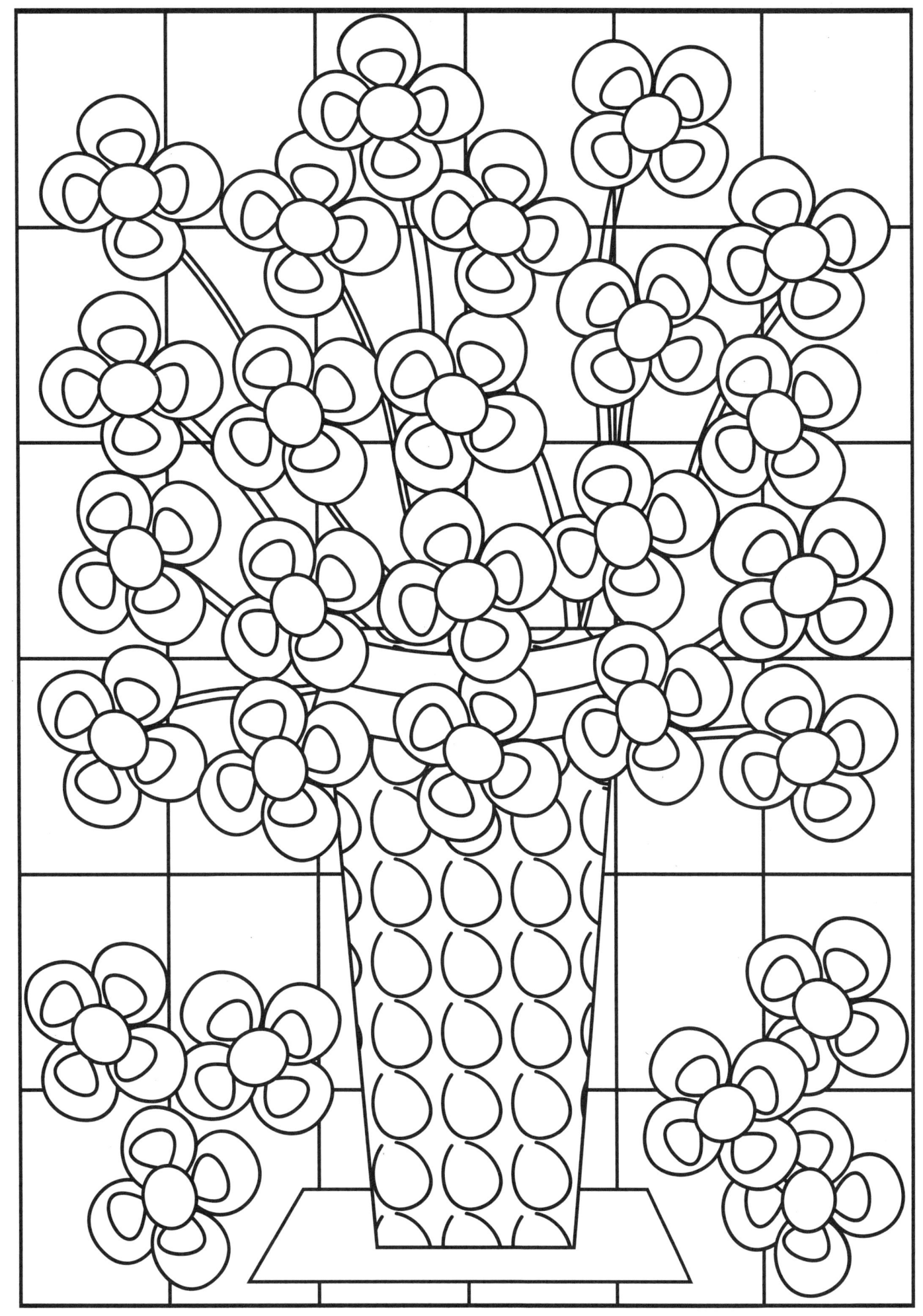

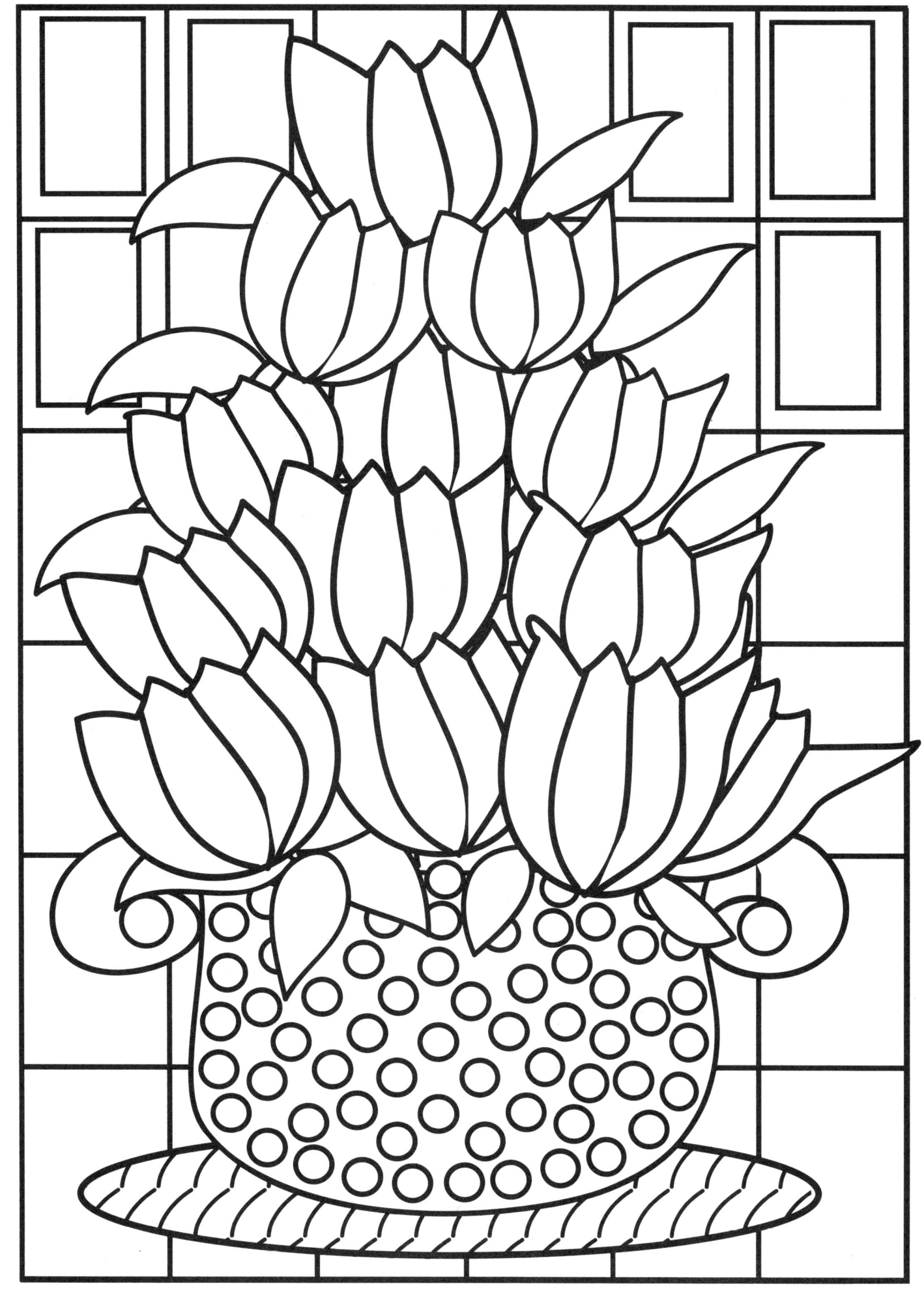

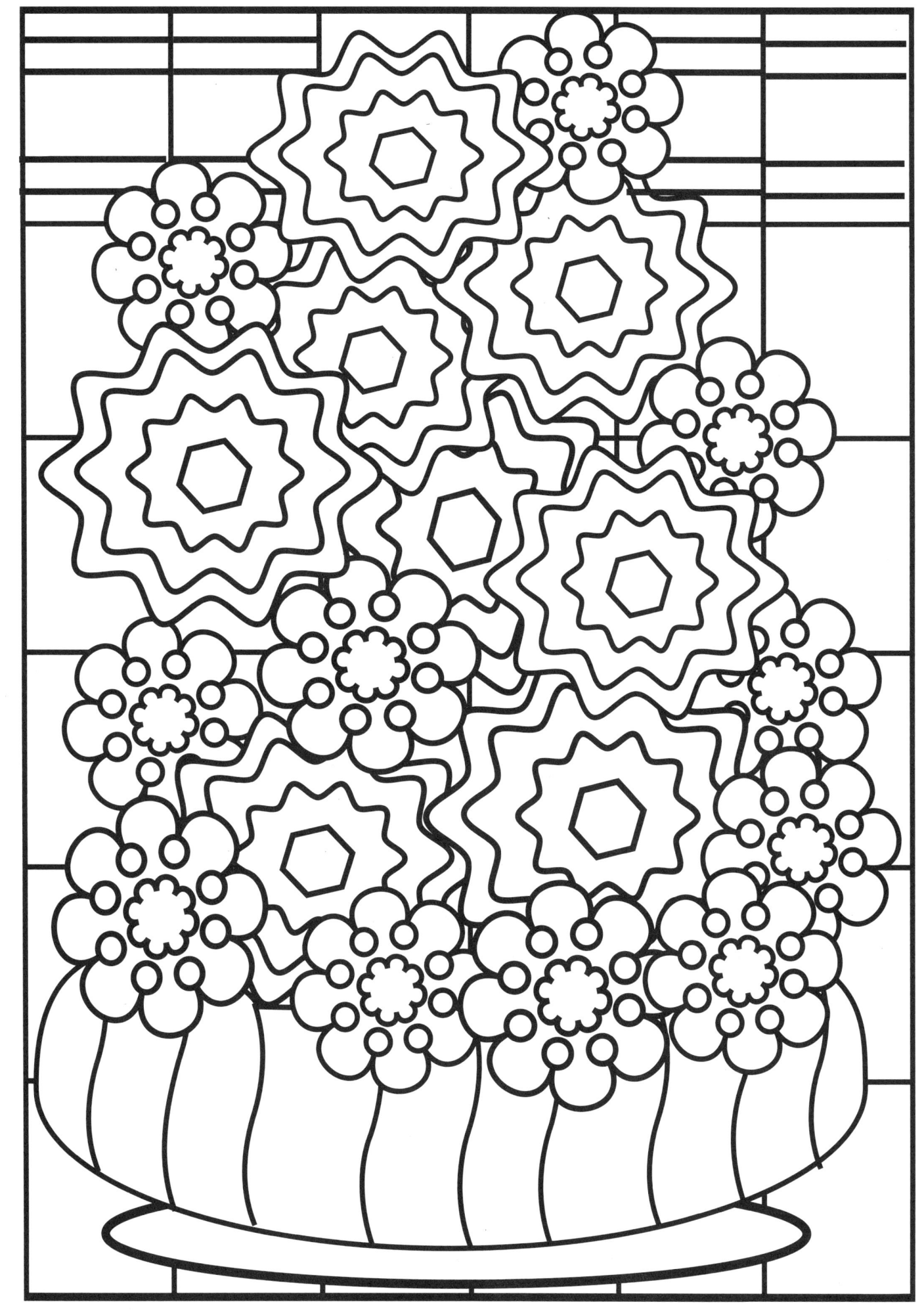

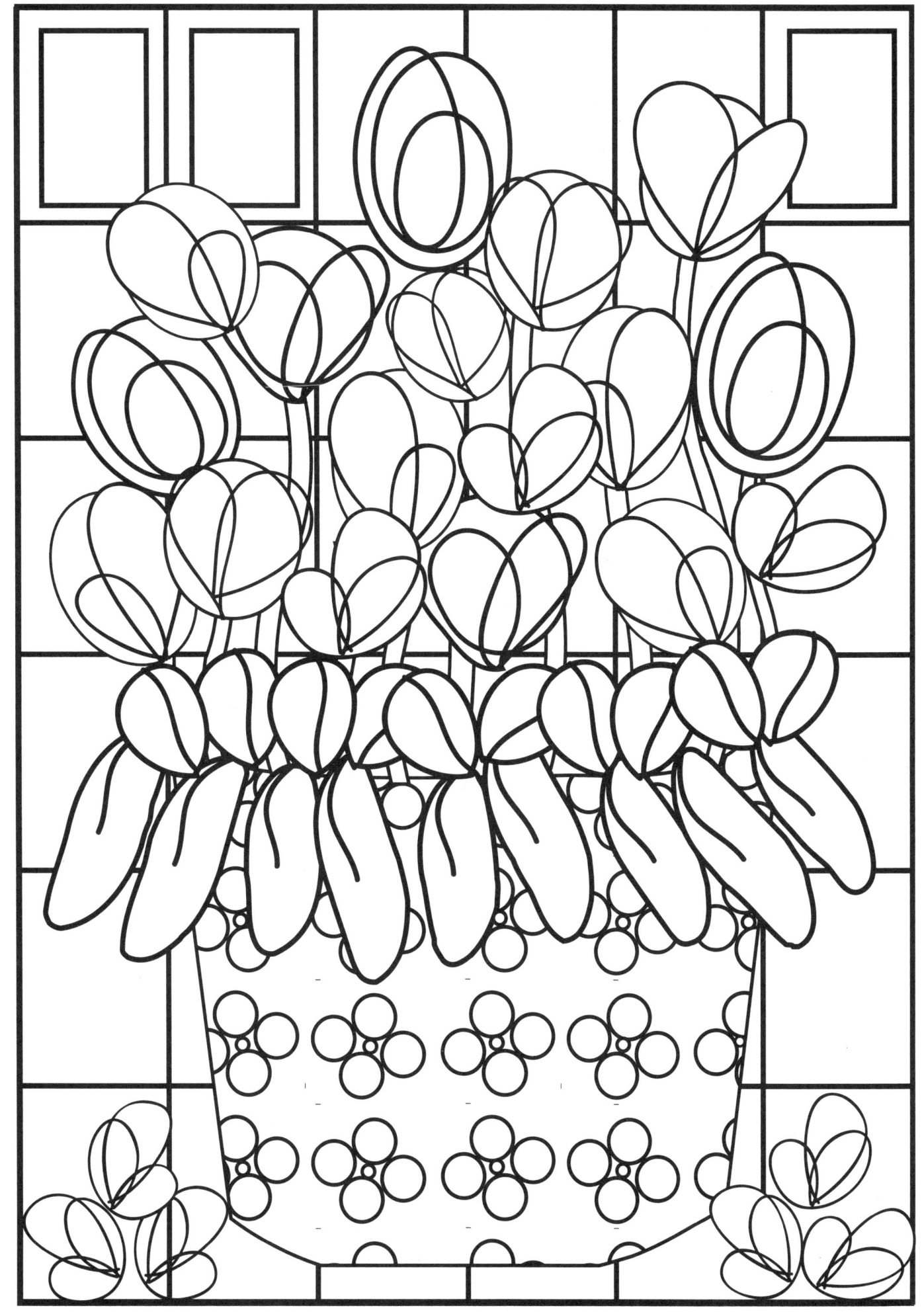

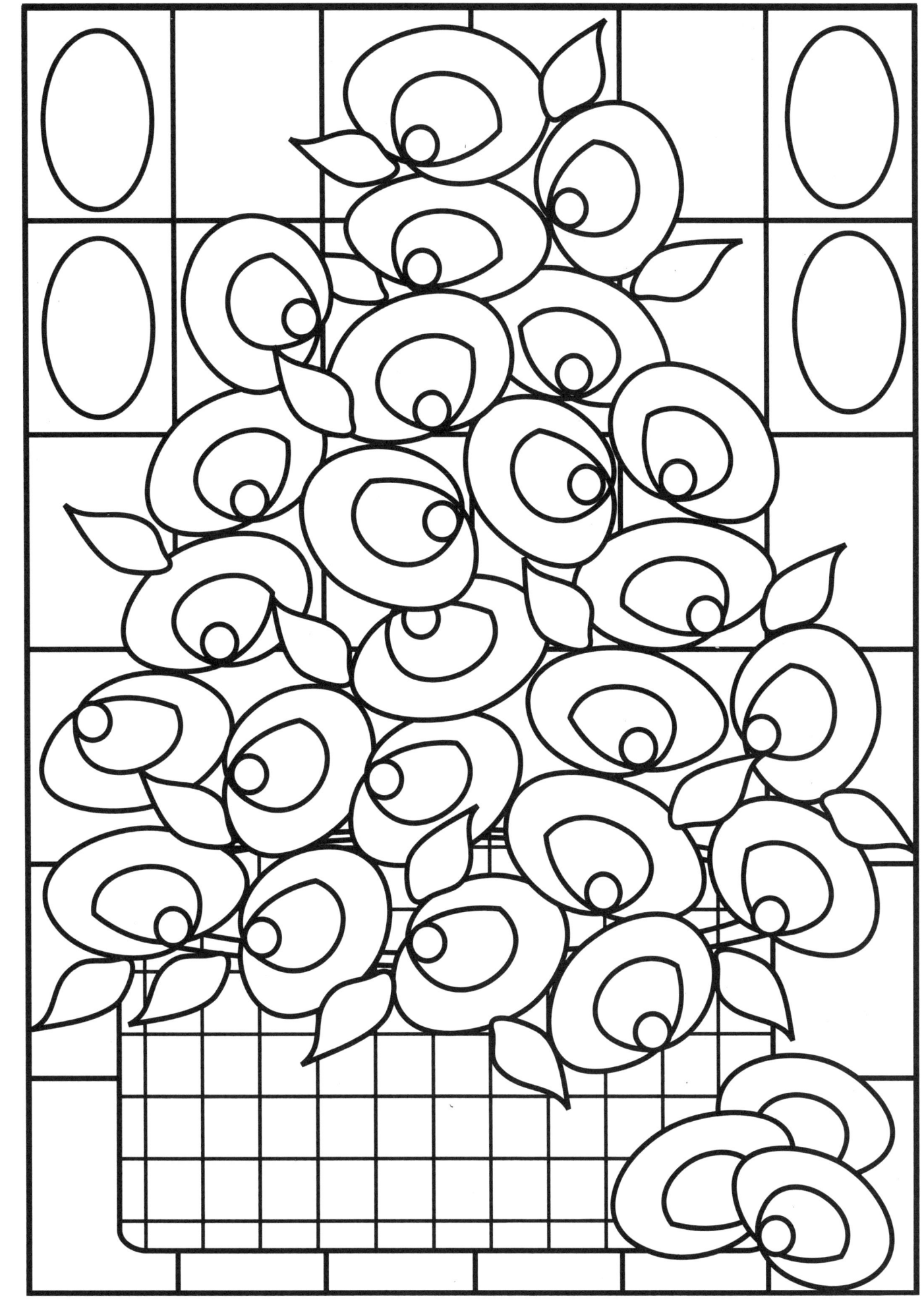

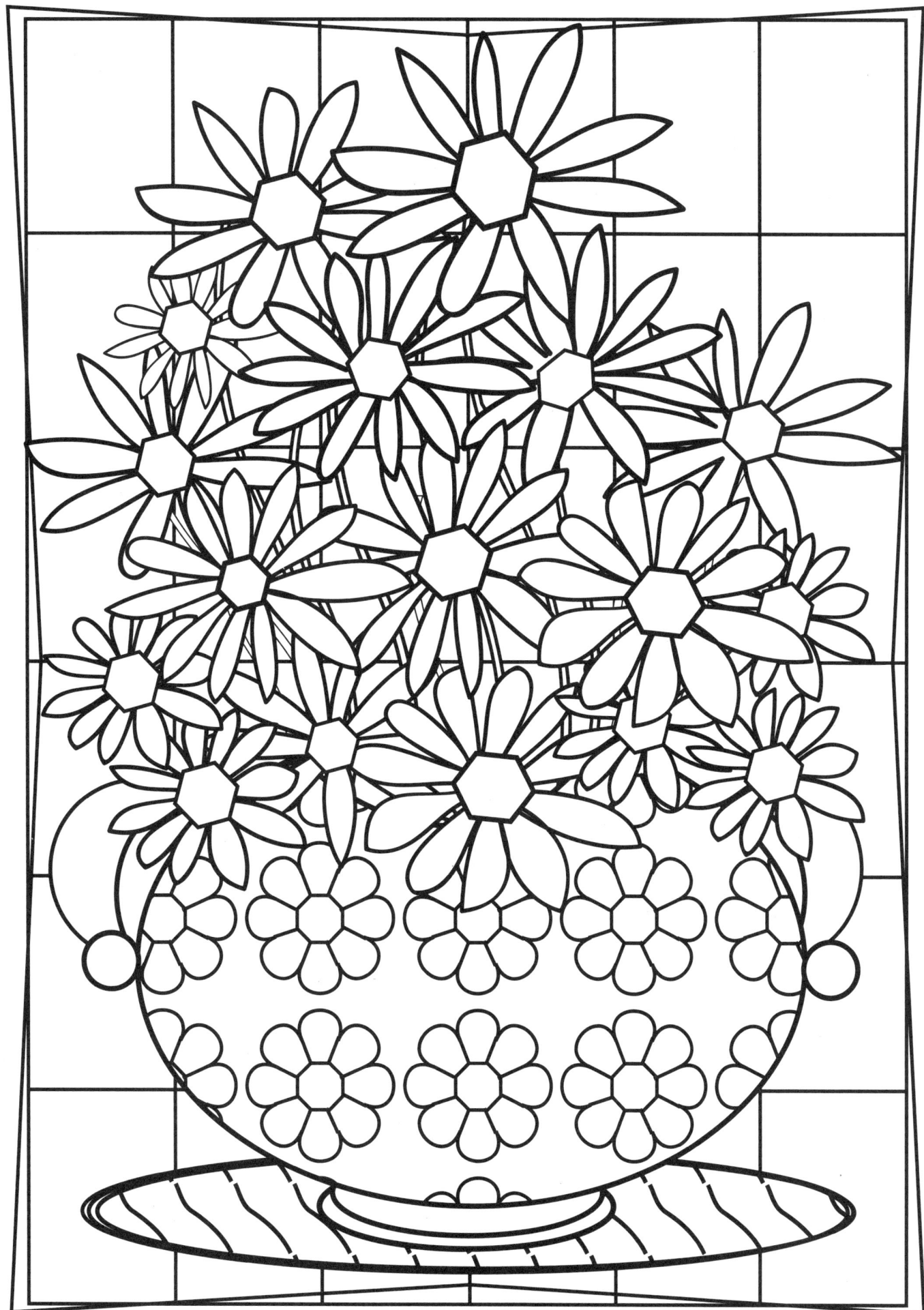

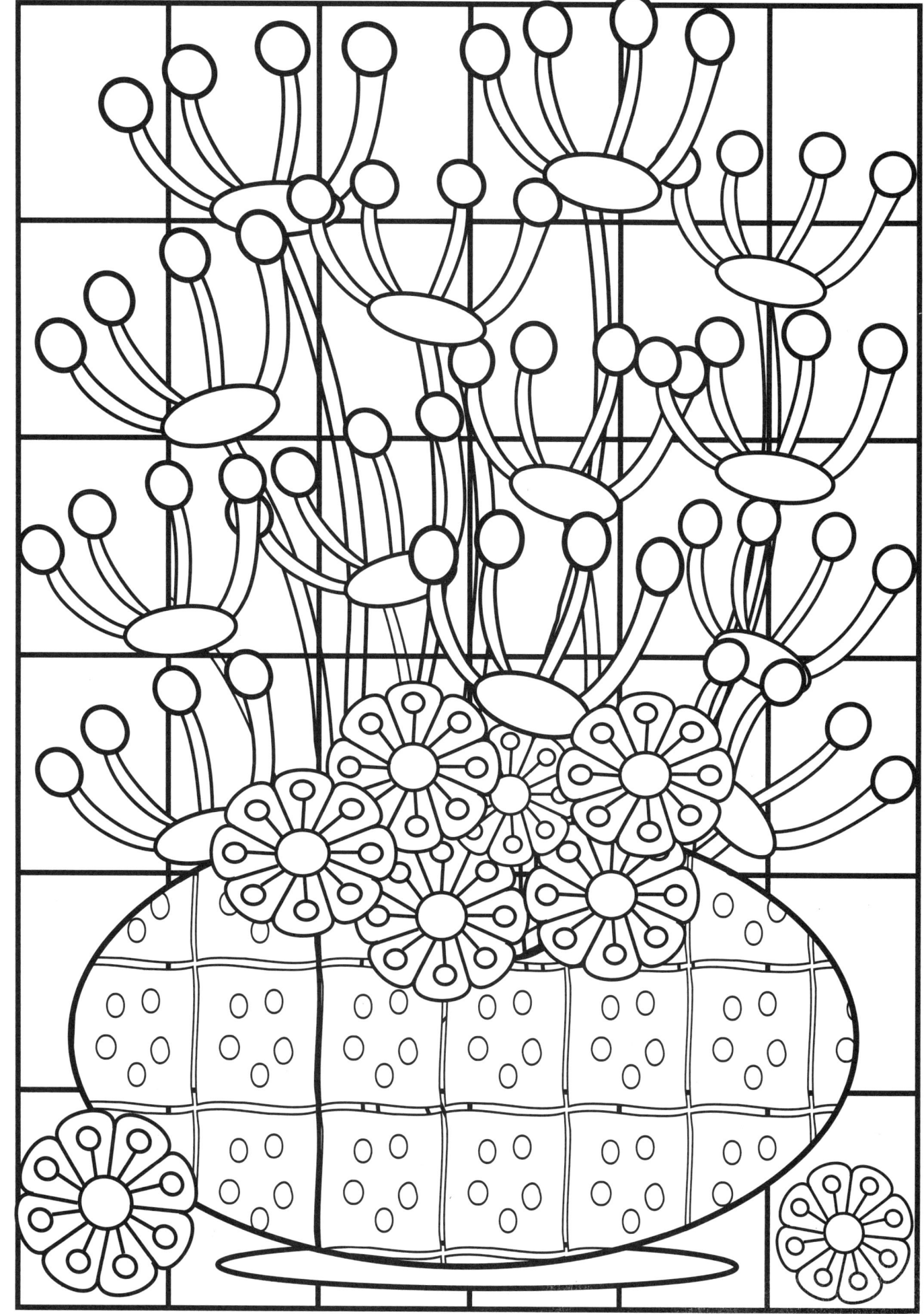

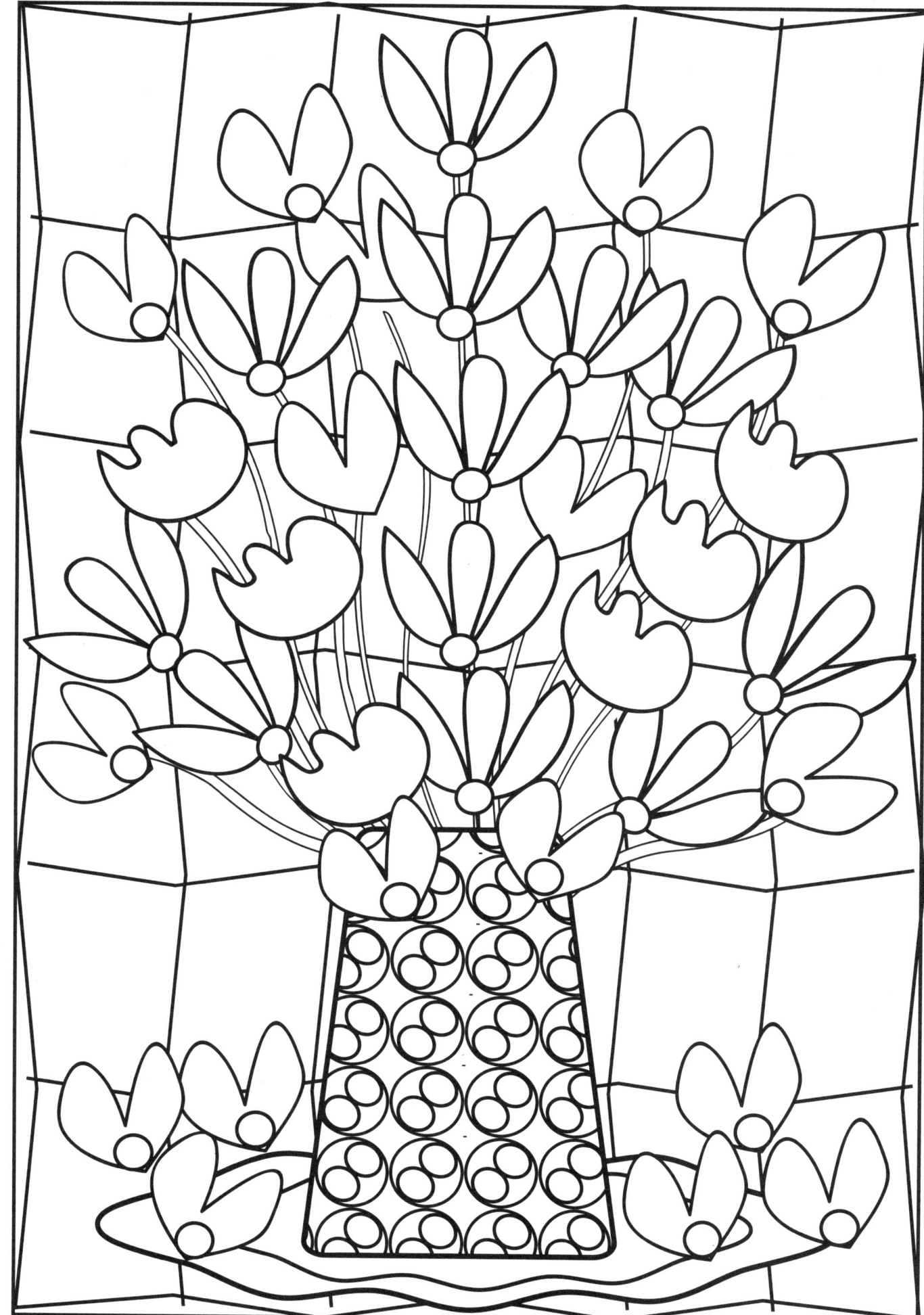

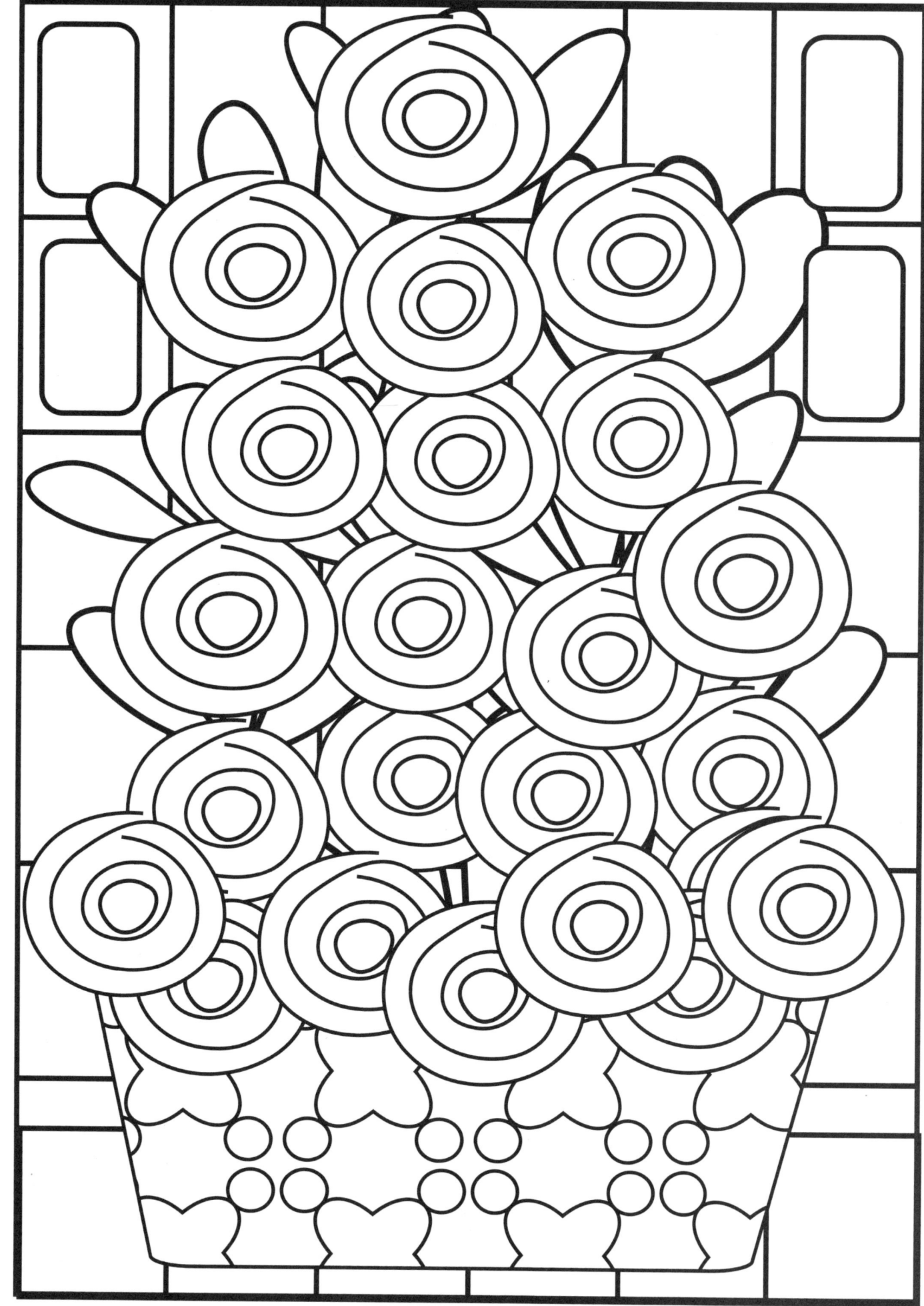

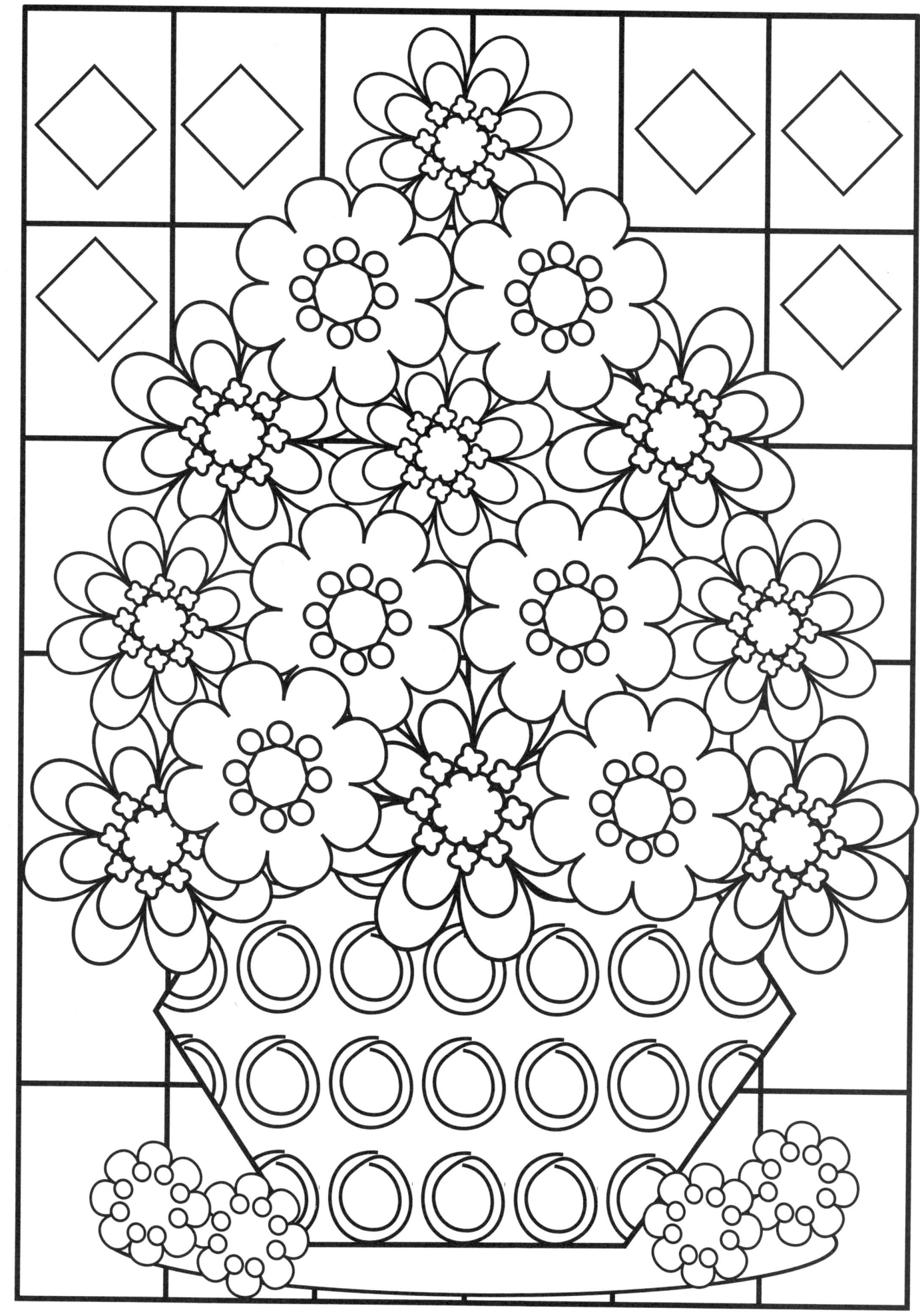

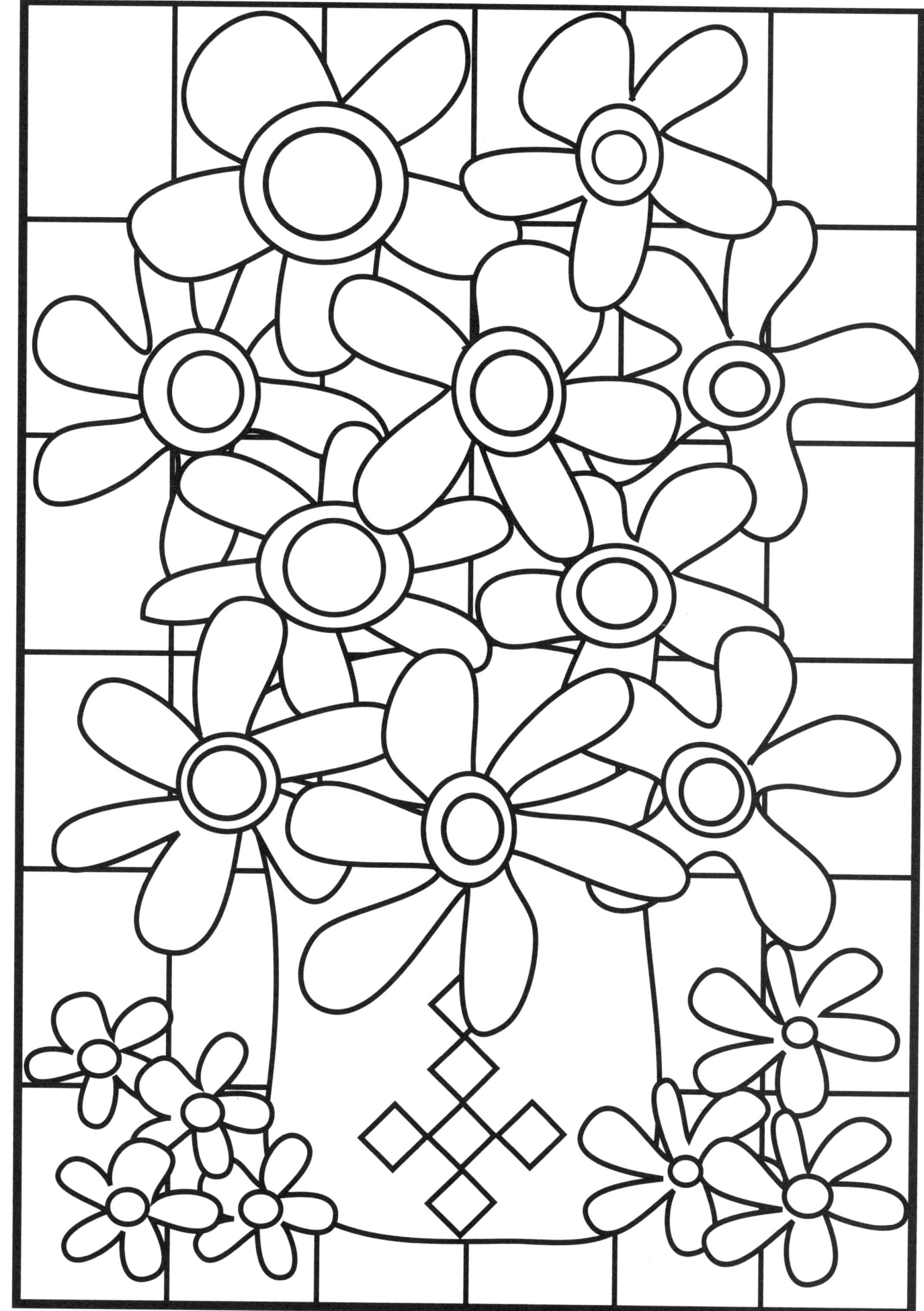

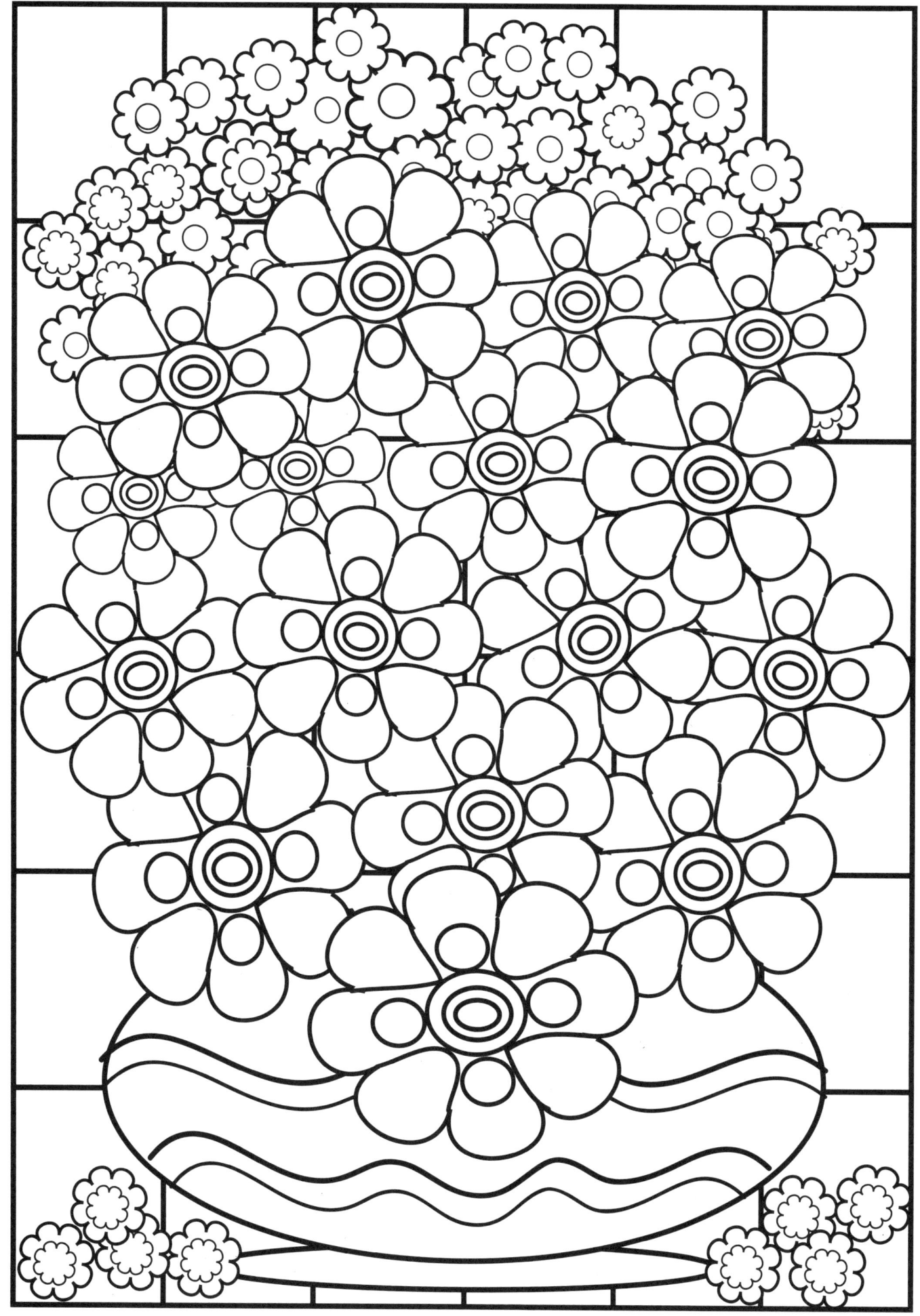

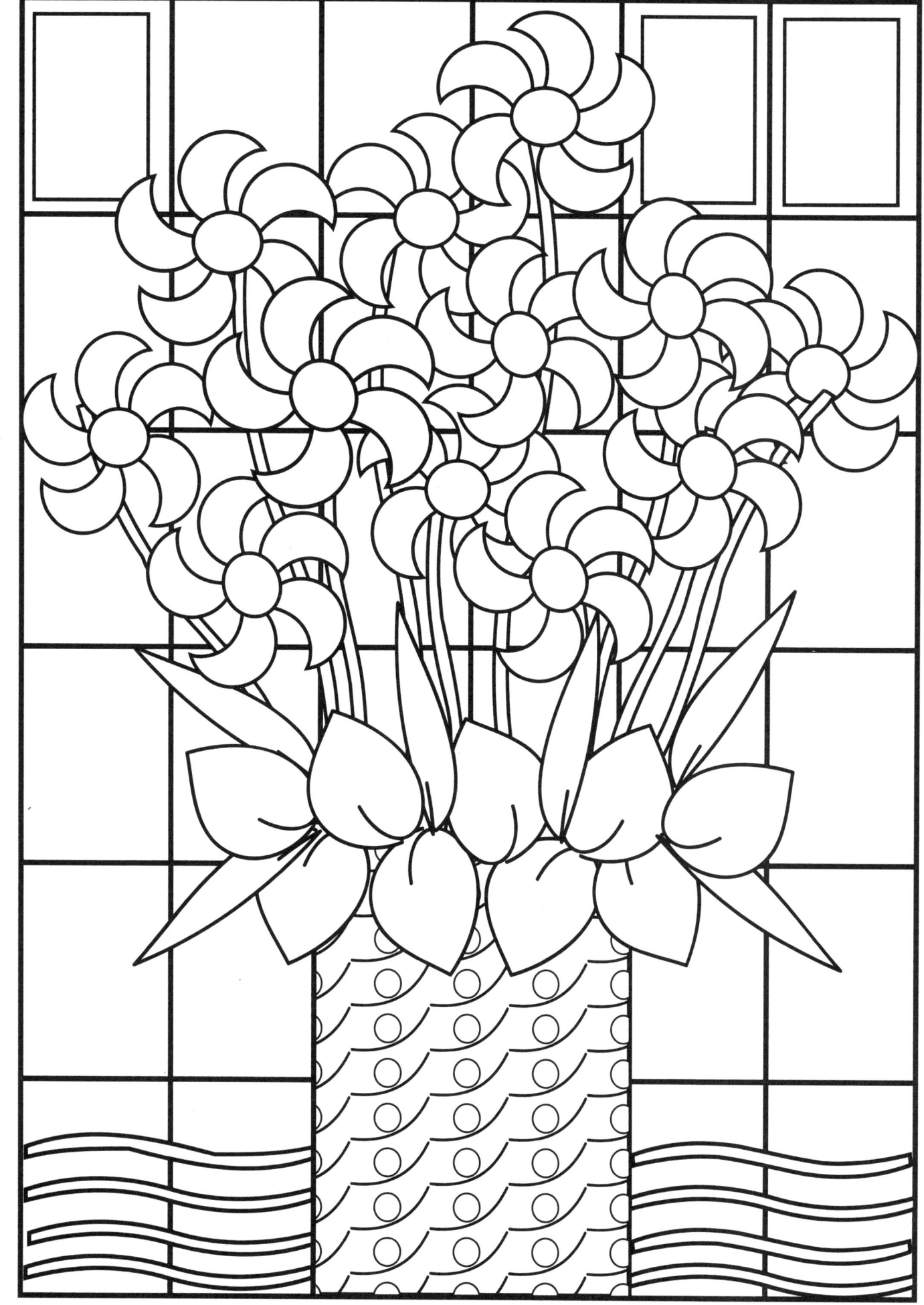